STUPID PUNS FOR NO REASON

Elizabeth Challinor

SWITCH THE FUCKING TAP OFF

NOT
GOOD
ENOUGH

JUST DON'T KNOW

ABSOLUTE

HIBERNA TING

BRE ATHE THRO UGH

DON'T EVEN RECOGNISE

DIRTY
DISHES IN
A
DISHWASH
ER

NOT GOOD ENOUGH

DOES IT REALLY MATTER?

ANYTHING
TO
COMPLAIN
ABOUT

BECOME A SAUSAGE ROLL

SO SHIT

RHYTHMIC
GYMNASTICS

SICK TO

DEATH

OF

PEOPLE

PROBABLY DISLIKE THEM

MORE POETIC, BUT

LOUDER
THAN NECESSARY

BOTTLE AT
AN ARTIST

THIS TIME EVERY YEAR

GETTI NG NOWH ERE

LEAVE

GENUINELY

CHICKEN NUGGETS EXIST

3 EXTRA MONTHS

INA
BILIT
Y

FED UP OF TRYING TO

LOCK
HER
OUTSIDE

PASSIVE

AGGRESSIVE

TOO
HUNGRY
FOR THIS
SHIT

REALLY
ANGRY

www.ingramcontent.com/pod-product-compliance
Lightning Source LLC
Chambersburg PA
CBHW072309170526
45158CB00003BA/1247